DRAW
DINOSAURS

by Doug DuBosque

SCHOLASTIC INC.

New York Toronto London Auckland Sydney
Mexico City New Delhi Hong Kong

ISBN 0-439-23705-X

12 11 10 9 8 7 6 5 4 3 2 0 1 2 3 4 5/0

Printed in the U.S.A. 40
First Scholastic printing, September 2000

Contents

Rods and joints ...**4**

How to make arms and legs look real!

Supplies...**6**

What you need to start your dino-drawing adventures

Linosaurs..**7**

For an easy start, draw one line at a time

Ovalsaurs..**21**

For more flexibility, build from this basic shape

Trianglesaurs ..**39**

Sometimes, triangles will jump out at you. Draw them!

Solidsaurs...**51**

For maximum effect, build forms into your drawing

Index ..**63**

Rods and Joints

Look carefully at this *Tyrannosaurus* skeleton.

Can you find the shoulder joint? The knee?

Can you see where the legs and arms bend?

To make the legs of a dinosaur look good in your drawing, learn about the skeleton. Look at one whenever you can when drawing a dinosaur.

Draw *rods* (lines) to show parts of arms and legs. Draw *joints* (circles) where they bend.

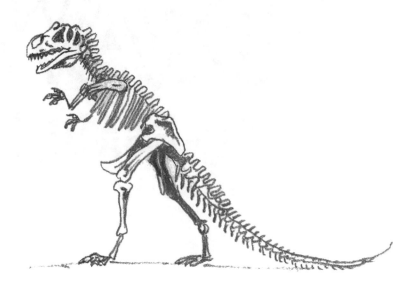

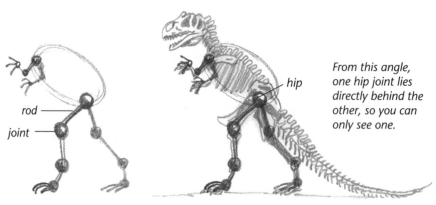

rod
joint

hip

From this angle, one hip joint lies directly behind the other, so you can only see one.

Always draw rods and joints very lightly, so you can either erase them or cover them with shading. You don't want them as part of your final drawing, but they do give you a powerful tool to use along the way!

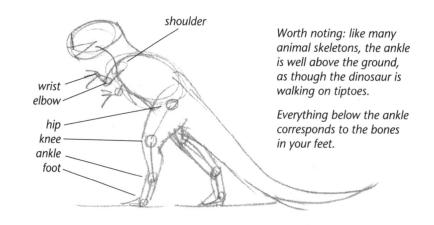

shoulder

wrist
elbow

hip
knee
ankle
foot

Worth noting: like many animal skeletons, the ankle is well above the ground, as though the dinosaur is walking on tiptoes.

Everything below the ankle corresponds to the bones in your feet.

Always start out *lightly*!

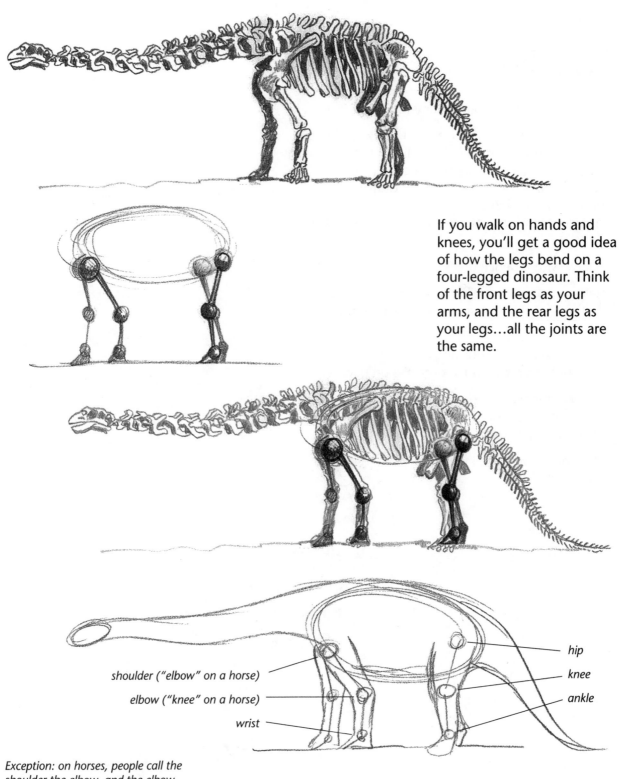

If you walk on hands and knees, you'll get a good idea of how the legs bend on a four-legged dinosaur. Think of the front legs as your arms, and the rear legs as your legs…all the joints are the same.

shoulder ("elbow" on a horse)

elbow ("knee" on a horse)

wrist

hip

knee

ankle

Exception: on horses, people call the shoulder the elbow, and the elbow the knee…even though they call the part between them the forearm! It makes no sense at all …(to me).

Supplies...

You can draw with just about anything.

People in caves used dried clay and black stuff out of the fire pit, and we're still talking about their drawings 25,000 years later! But caves, charcoal, mud and torches do not make for an optimal drawing environment. So find a comfortable place to draw – with decent light, so you can see what you're doing.

Draw with a pencil that's longer than your finger.

 Find an eraser – the one on your pencil will disappear quickly.

Plan to keep your drawings – you'll find instructions for a simple portfolio on page 62.

For practice drawings, use recycled paper – for example, draw on the back of old photocopies or computer printouts.

Sharpen your pencil when it gets dull!

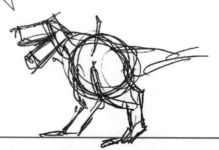

Positive attitude!
Persistence!
Practice!

LINOSAURS

Sometimes, you can make a dinosaur starting with simple lines.

Can you spot the dinosaurs lurking in these curves?

Camarasaurus

CAM-AR-A-SAW-RUS

"Chambered lizard." Late Jurassic; Colorado, Wyoming, Utah and Oklahoma USA. Up to 60 feet (18m) long; weighed perhaps 20 tons. Because of long nasal openings on the top of its skull, some people think it had a trunk like an elephant (draw that if you want)!

Draw a long, swooping line.

Add a partial circle hanging from the middle of it.

Draw another line to complete the tail.

Add another line for the neck. Draw the mouth.

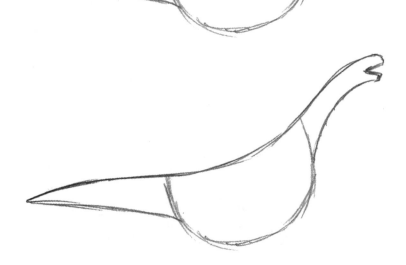

Always start out *lightly!*

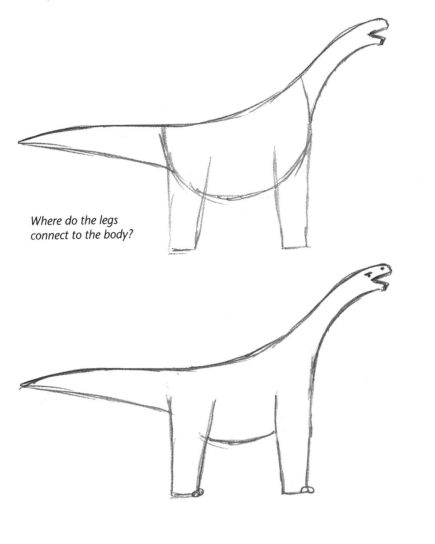

Where do the legs connect to the body?

Now draw the legs. Since the legs are straight, you don't really need rods and joints to draw them.

Add the eye, a nostril and toe nails. Carefully erase lines you no longer need: in the legs, on the tail and on the neck.

- Finish your drawing by adding texture, shading, and background. (See pages 60-61 for ideas.)

- Look at your drawing in a mirror (or through the back of the paper) to spot areas you can improve.

- While your pencil is sharp, go over fine details and make lines cleaner. As it gets duller, add shading.

- Turn your drawing as you draw to avoid smudging it with your hand.

- Finally, clean up any smudges with your eraser.

Allosaurus

AL-o-SAW-rus

"Other lizard." Late Jurassic; North America, Africa, Australia, perhaps Asia. Up to 39 feet (12m) long; weighed 1-2 tons. Lived long before Tyrannosaurus, and had longer arms with strong claws to hold its prey while it tore at it with teeth serrated like steak knives.

Start this drawing with a swooping line. Draw lightly!

Draw another line above the first, starting at one end and ending in the middle.

From the top line, add a smooth, curving line to complete the tail. At the other end, add lines for the neck and head. Make a bump where the eye will go. Leave room for the mouth.

Now lightly draw the leg. You may find it helpful to start with *rods and joints* (see pages 4-5).

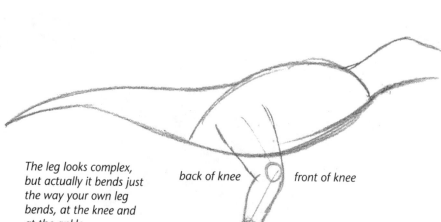

The leg looks complex, but actually it bends just the way your own leg bends, at the knee and at the ankle.

back of knee front of knee

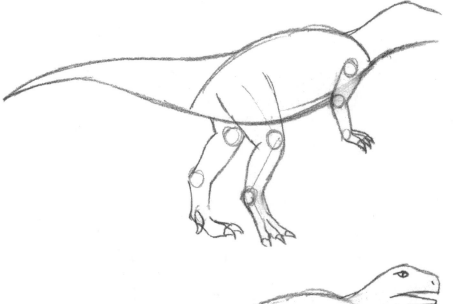

Add the other leg. Now your dinosaur looks as though it's moving!

Draw the arm.

Draw the other arm. Now add nose, eye and mouth.

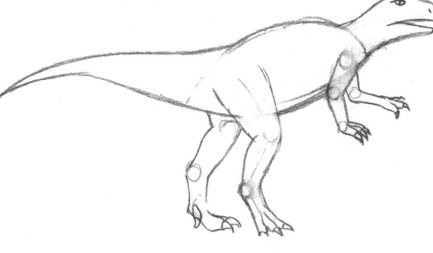

- Finish your drawing by adding texture, shading, and background. (See pages 60-61 for ideas.)

- Look at your drawing in a mirror (or through the back of the paper) to spot areas you can improve.

- While your pencil is sharp, go over fine details and make lines cleaner. As it gets duller, add shading.

- Turn your drawing as you draw to avoid smudging it with your hand.

- Finally, clean up any smudges with your eraser.

Awesome Allosaurus!

Stenonychosaurus

STEN-oh-NIKE-o-SAW-rus

"Narrow claw lizard." Cretaceous; southern Alberta, Canada. 6 feet (2m) long; weighed 60-100 lbs (27-45 kg). Has been called the most intelligent dinosaur because of its large brain size (relatively speaking), which probably gave it fast reflexes for catching small prey.

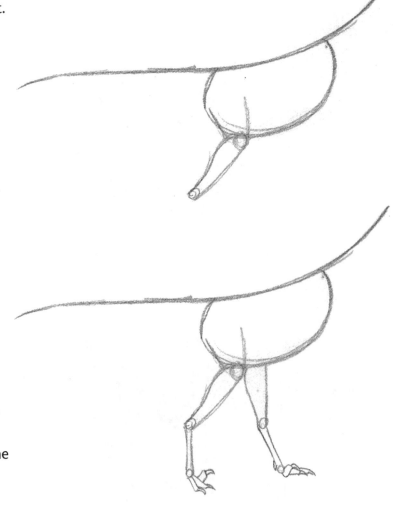

Start with a long slanting and curving line. Draw another curved line under it.

Using circles for the joints, add the top part of the leg.

Now add the thinner bottom of the leg, and the foot. Pay close attention to the details of the foot!

When you've completed the first leg, draw the second.

Notice that each foot has a sickle claw that sticks up.

Always start out *lightly*!

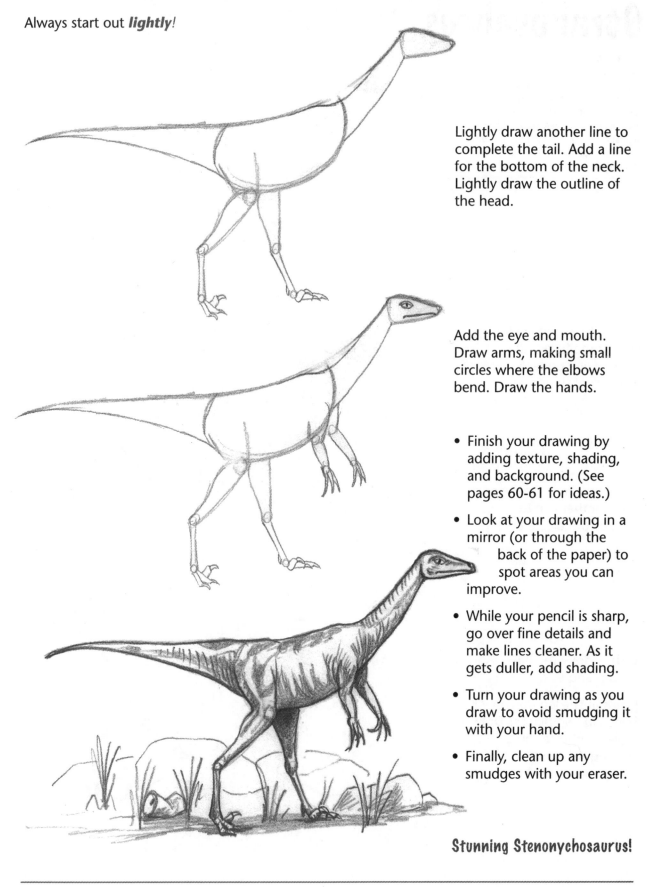

Lightly draw another line to complete the tail. Add a line for the bottom of the neck. Lightly draw the outline of the head.

Add the eye and mouth. Draw arms, making small circles where the elbows bend. Draw the hands.

- Finish your drawing by adding texture, shading, and background. (See pages 60-61 for ideas.)

- Look at your drawing in a mirror (or through the back of the paper) to spot areas you can improve.

- While your pencil is sharp, go over fine details and make lines cleaner. As it gets duller, add shading.

- Turn your drawing as you draw to avoid smudging it with your hand.

- Finally, clean up any smudges with your eraser.

Stunning Stenonychosaurus!

Ouranosaurus

OO-RAN-O-SAW-RUS

"Brave monitor lizard." Early cretaceous; Niger, West Africa. Ate plants. 23 feet (7m) long. Had a tall fin along its back and tail, probably for regulating body temperature. Closely related to Iguanodon, and like it had spike-like thumbs.

Start with a long, swooping line for the back. Add a curving line underneath for the bulk of the body.

Draw two lines for the neck. Add another line to make the bottom of the tail.

Lightly draw the head. Add mouth and eye.

Look at the leg–see how it bends in two places? Draw it, very lightly at first, starting with *rods and joints* (see pages 4-5).

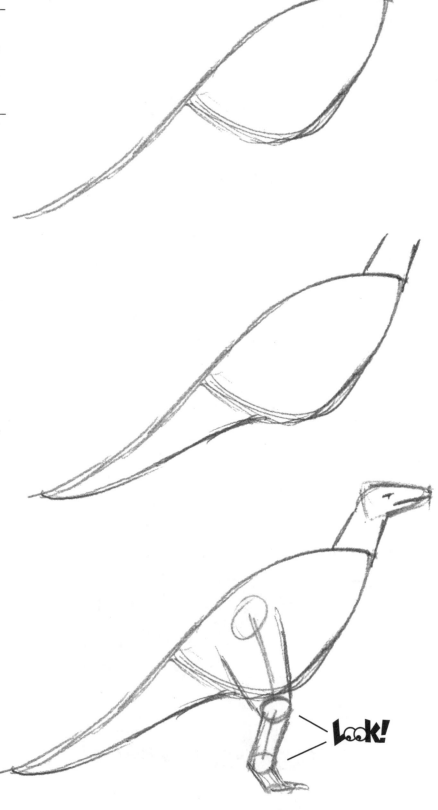

Always start out *lightly*!

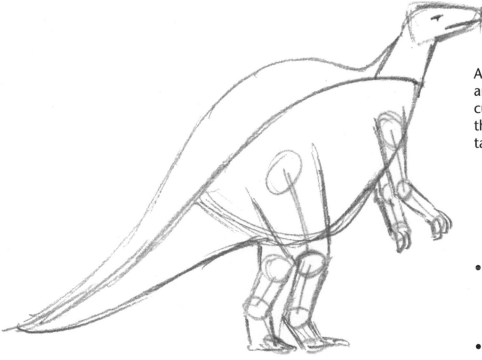

Add the other leg. Draw the arms and hands. Add the curving fin, running from the neck to the tip of the tail.

- Finish your drawing by adding texture, shading, and background. (See pages 60-61 for ideas.)

- Look at your drawing in a mirror (or through the back of the paper) to spot areas you can improve.

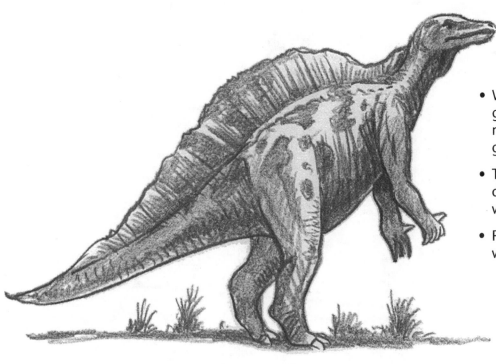

- While your pencil is sharp, go over fine details and make lines cleaner. As it gets duller, add shading.

- Turn your drawing as you draw to avoid smudging it with your hand.

- Finally, clean up smudges with your eraser.

Anchiceratops

AN-KI-SER-A-TOPS

"Close-horned face." Cretaceous; Alberta, Canada. Ate plants. 20 feet (6m) long. Had a long neck frill and one long horn above each eye, with a smaller one on the nose. The frill was probably for display, not for defense.

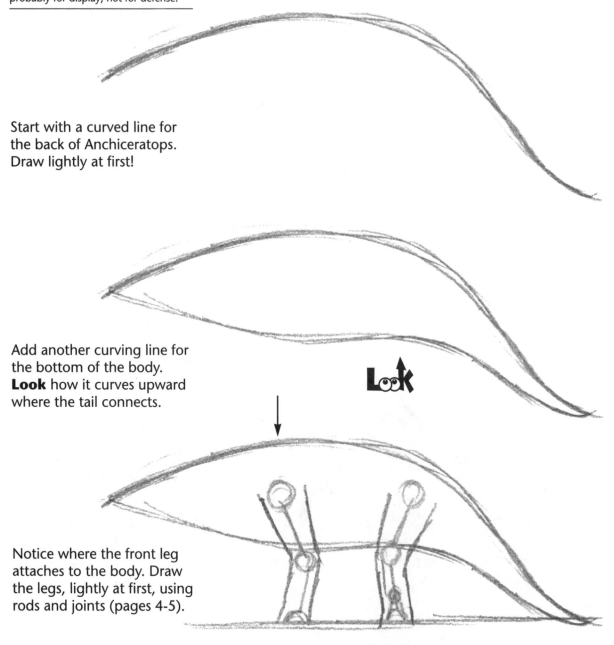

Start with a curved line for the back of Anchiceratops. Draw lightly at first!

Add another curving line for the bottom of the body. **Look** how it curves upward where the tail connects.

Notice where the front leg attaches to the body. Draw the legs, lightly at first, using rods and joints (pages 4-5).

Notice that the legs bend toward each other.

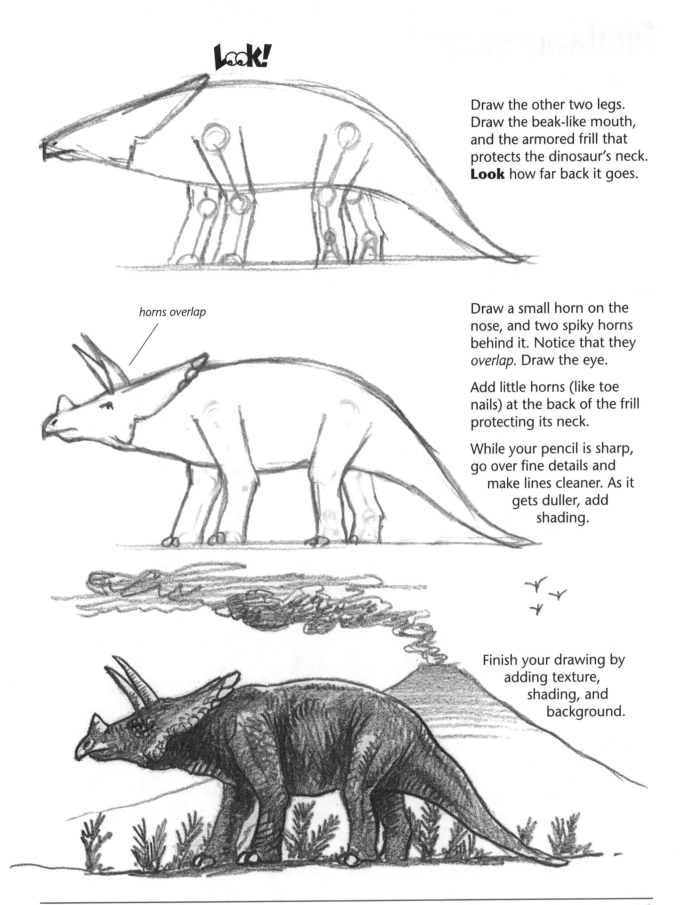

Look!

Draw the other two legs. Draw the beak-like mouth, and the armored frill that protects the dinosaur's neck. **Look** how far back it goes.

horns overlap

Draw a small horn on the nose, and two spiky horns behind it. Notice that they *overlap.* Draw the eye.

Add little horns (like toe nails) at the back of the frill protecting its neck.

While your pencil is sharp, go over fine details and make lines cleaner. As it gets duller, add shading.

Finish your drawing by adding texture, shading, and background.

Tuojiangosaurus

TWA-JAN-GO-SAW-RUS

"Tuojiang lizard." Late Jurassic; south-central China. Ate plants, probably grazing like a horse. 20 feet (6m) long. Of all Stegosaurus-type skeletons found in Asia, this one is the best preserved.

Draw a long line, curving up from the tail and back down to the end of the nose. Add another curve for the belly.

Draw additional lines to complete the head and tail.

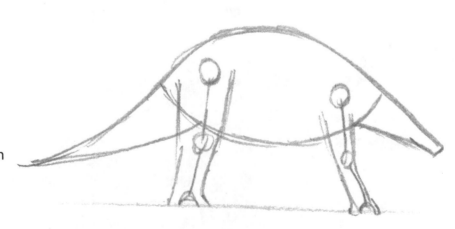

Draw legs. Make the back legs bigger and longer than the front legs.

Always start out *lightly*!

pointy plates

spikes

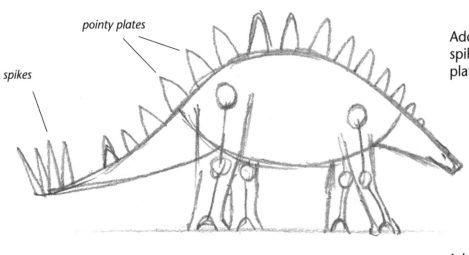

Add two more legs. Draw spikes on the tail and pointy plates on the back.

Front plates overlap rear plates.

Add the eye and mouth. Erase lines where tail and legs overlap the body.

To add depth to your drawing, make a second row of pointy plates.

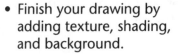

- Finish your drawing by adding texture, shading, and background.

- While your pencil is sharp, go over fine details and make lines cleaner. As it gets duller, add shading.

- Turn your drawing as you draw to avoid smudging it with your hand.

- Finally, clean up any smudges with your eraser.

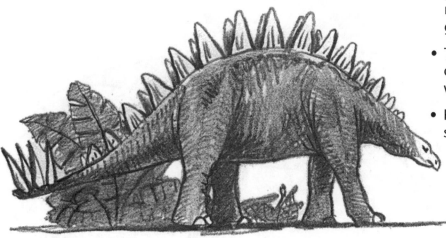

Dsungaripterus

TSUN-GA-RIP-TER-US

Early Cretaceous. Skull 16 inches (41cm) long. Unusual upward-curving beak – for eating shellfish and snails? Who knows?

Start with a slanting line for the main axis of the body.

At a *right angle*, draw the curving lines of the head.

Add lines for the top of the wings, and the fingers where the wing bends.

Add curved lines for the bottom of each wing. Draw feet, and the oval at the end of the tail.

Finally, draw the lines of the arms and a few veins in the wing. Add shading.

Dsungaripterus was a type of Pterosaur (TER-o-sor). Pterosaurs weren't actually dinosaurs, they were flying reptiles.

CHAPTER 2
OVALSAURS

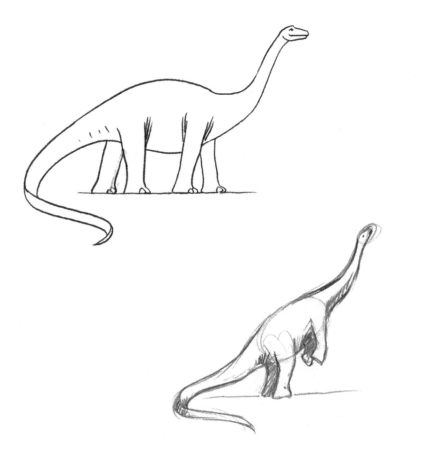

It's great to be able to draw a dinosaur in one position. But what if you want to draw it moving around?

How could you make it reach for food in a tree?

Or walk?

You'll gain flexibility in drawing different dinosaur poses when you start your drawing with ovals....

Apatosaurus

A-PAT-O-SAW-RUS

"Deceptive reptile." Late Jurassic; Colorado, Oklahoma, Utah and Wyoming, USA. Ate plants. 70 feet (21m) long; weighed 33 tons. One of the best-known dinosaurs. Has also been called *Brontosaurus* ("thunder reptile). Shorter than *Diplodocus* but much heavier.

Lightly draw two overlapping ovals for the body.

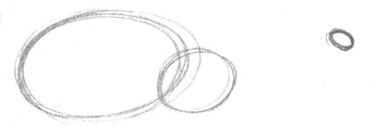

Make a much smaller, tilted oval for the head. Notice how far it is from the body.

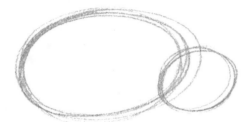

From the top of the head, draw a smooth curving line touching the tops of larger ovals to make the back.

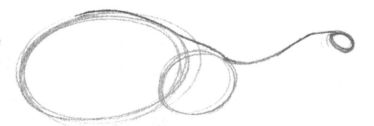

Add the line for the bottom of the neck. Add details to the face.

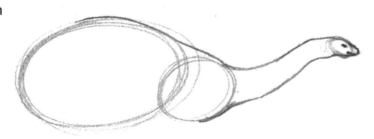

Always start out *lightly!*

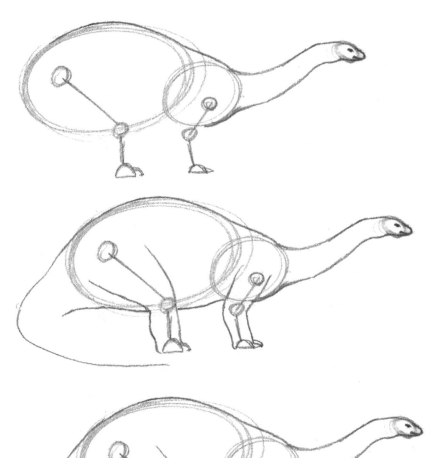

Using rods and joints (see pages 4-5), place the legs in the first two ovals you drew.

Then add thickness to the legs by making their outlines. Extend the belly line back to the beginning of the tail. *Don't draw the bottom of the tail yet!*

Add the curving line of the top of the tail.

Now add the bottom of the tail. **Look** at the way it runs into the other line. Draw the other line (shown with dashes) and you've got a tail that looks like it's curving toward you!

- While your pencil is sharp, go over fine details and make lines cleaner.

- Turn your drawing as you draw to avoid smudging it with your hand.

- Finally, clean up any smudges with your eraser.

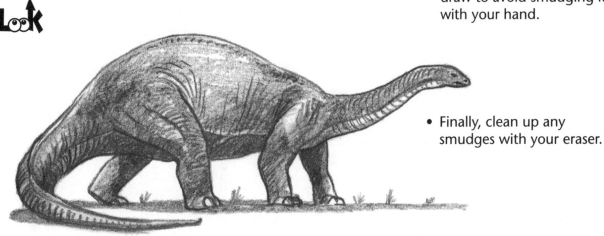

Triceratops

TRI-**CER**-A-TOPS

"Three-horned face." Cretaceous; North America, from Alberta and Saskatchewan to Colorado and South Dakota. Up to 30 feet (9m) long; weighed 6 tons. Cores of the horns measure up to 3 ft (90cm); actual horns may have been much longer.

Draw a light, horizontal oval.

Using rods and joints (see pages 4-5), construct the front and rear leg. Make the hip higher than the shoulder. Notice how the legs bend toward each other.

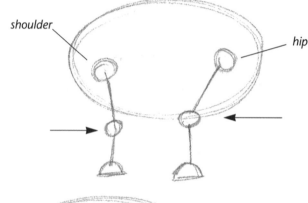

shoulder

hip

Carefully outline the legs and draw the toes. Then lightly erase the rods and joints.

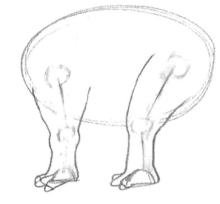

Now draw the other legs.

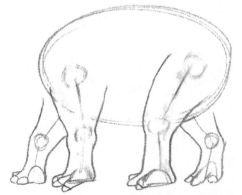

Always start out *lightly*!

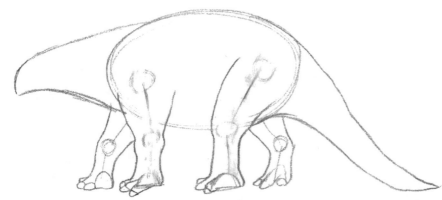

Draw the tail, making the top and bottom of it blend right into the oval. Draw the shape of the head—*very lightly*!

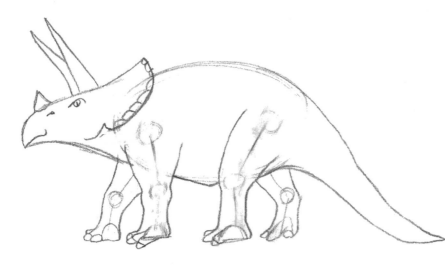

Add the eye, nose and mouth. Draw the three horns. Make the curved frill above the neck.

- Finish your drawing by adding texture, shading, and background. (See pages 60-61 for ideas.)

- Look at your drawing in a mirror (or through the back of the paper) to spot areas you can improve.

- While your pencil is sharp, go over fine details and make lines cleaner. As it gets duller, add shading.

- Turn your drawing as you draw to avoid smudging it with your hand.

- Finally, clean up any smudges with your eraser.

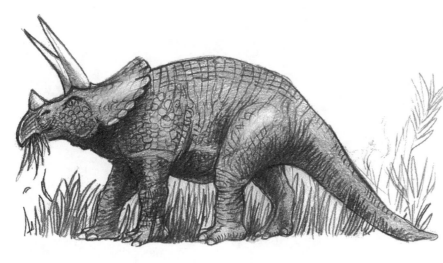

T'riffic Triceratops!

Parasaurolophus

PAR-A-SOR-O-LO-FUS

"Beside Sauralophus." Cretaceous; Alberta, Utah and New Mexico. 33 feet long (10m). The long (up to 6 ft/1.8m) crest on its head was probably a visual signal to other dinosaurs. It might have supported brightly colored skin connected to the neck, like a flag or banner. It wasn't a snorkel!

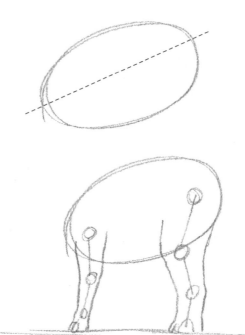

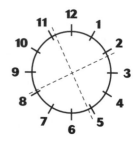

Use the clock face to compare angles of lines and ovals.

Lightly draw an oval, with one end higher than the other.

Draw the closest two legs, using rods and joints (pages 4-5). Notice how much bigger the rear leg is than the front leg.

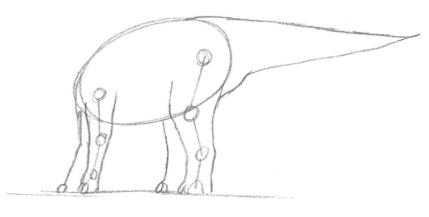

Add the other two legs, and the straight, pointed tail.

Lightly draw a circle for the head. Add the curving neck lines, then the crest on top and the jaws.

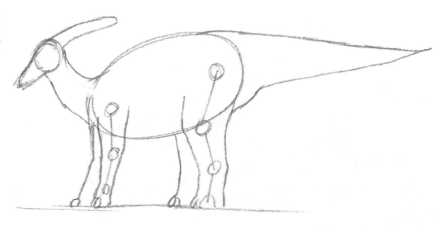

Always start out **lightly**!

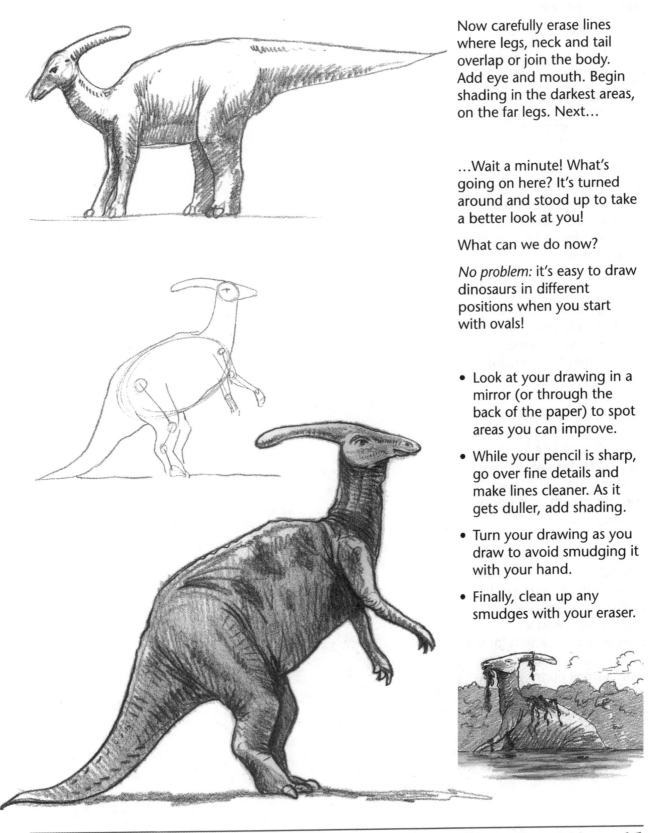

Now carefully erase lines where legs, neck and tail overlap or join the body. Add eye and mouth. Begin shading in the darkest areas, on the far legs. Next...

...Wait a minute! What's going on here? It's turned around and stood up to take a better look at you!

What can we do now?

No problem: it's easy to draw dinosaurs in different positions when you start with ovals!

- Look at your drawing in a mirror (or through the back of the paper) to spot areas you can improve.

- While your pencil is sharp, go over fine details and make lines cleaner. As it gets duller, add shading.

- Turn your drawing as you draw to avoid smudging it with your hand.

- Finally, clean up any smudges with your eraser.

Ankylosaurus

AN-KY-LO-SAW-RUS

"Fused lizard." Late Cretaceous; Alberta, Canada; Montana, USA. Up to 35 feet (10.7m) long. Built like an army tank. Swung its tail as a weapon, but with its armor plating, could have done well to simply hunker down when things started to get ugly. Some ankylosaurs had spikes along the sides; others didn't.

Draw a horizontal oval for the body. Add a pointed head on one end. Draw the tail, two curving lines ending with an oval.

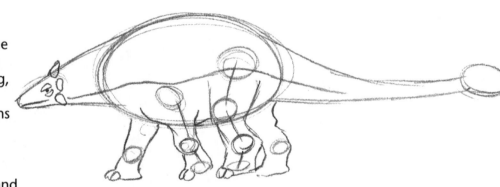

Use rods and joints (see pages 4-5) to draw the legs, then add their outlines. Don't forget the toenails!

Add the other two legs - notice where they join the body. Draw a line for the edge of the armor plating, all along the side. Draw eye and mouth, and horns on the face.

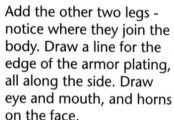

Carefully erase the rods and joints in the legs. Erase the main oval where the neck and tail join. Add a checkerboard pattern for the armor plates of the back, with a small bump in each square. Draw larger bumps on the neck and base of tail. Add a small row of bumps on the nose and tail.

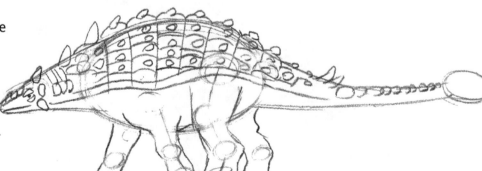

Always start out *lightly*!

Add a cast shadow on the ground underneath.

What is the darkest part of the dinosaur? Where is the lightest part?

- Finish your drawing by adding texture, shading, and background. (See pages 60-61 for ideas.)

- Look at your drawing in a mirror (or through the back of the paper) to spot areas you can improve.

- While your pencil is sharp, go over fine details and make lines cleaner. As it gets duller, add shading.

- Turn your drawing as you draw to avoid smudging it with your hand.

- Finally, clean up any smudges with your eraser.

Use your knowledge of ovals, rods and joints to make your ankylosaurus in different settings: perhaps using its tail as a weapon...

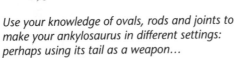

...or trying NOT to become someone's lunch!

Pachycephalosaurus

PAK-EE-SEF-O-LO-SAW-RUS

"Thick-headed lizard." Cretaceous; western North America. 15 feet (4.6m) long. Scientists have decided that the extraordinarily thick (10 inch/25cm) skulls served as crash helmets, and that male dinosaurs would butt heads to establish dominance, as males of some species still do today.

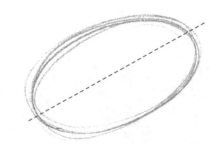

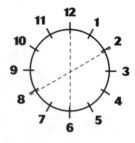

Use the clock face to compare angles of lines and ovals.

Begin by drawing a slanted oval for the dinosaur's body.

Add two swooping lines for the tail. Draw a vertical oval for the head, and two lines for the neck.

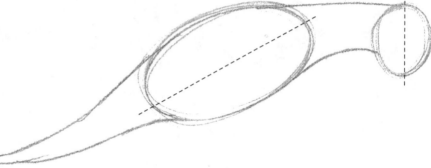

Using rods and joints (see pages 4-5), draw the hip, knee, ankle and foot of the leg. Then draw the joints of the shoulder, elbow, and hand.

Add a line for the ground.

Outline the leg and arm.

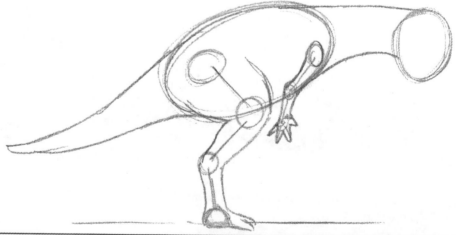

Always start out *lightly*!

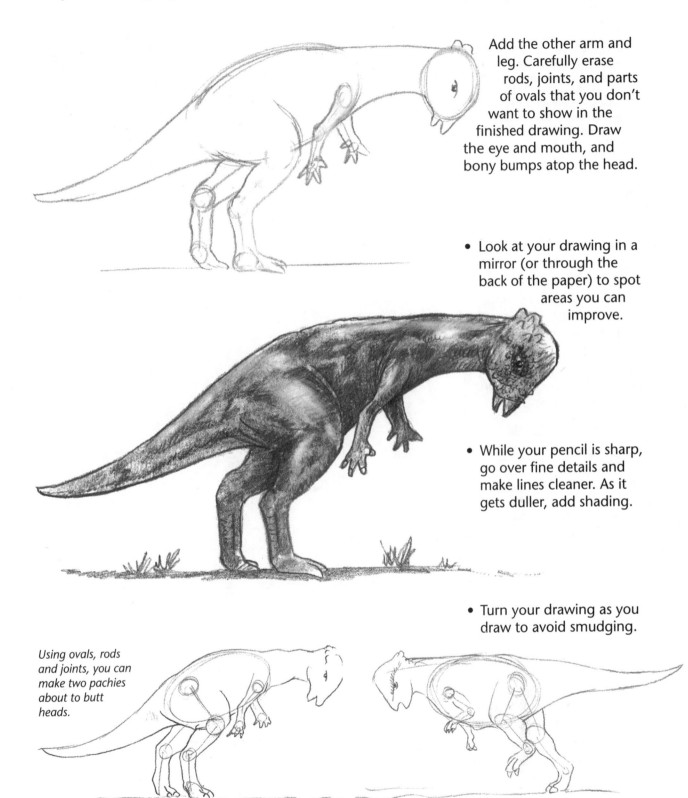

Add the other arm and leg. Carefully erase rods, joints, and parts of ovals that you don't want to show in the finished drawing. Draw the eye and mouth, and bony bumps atop the head.

- Look at your drawing in a mirror (or through the back of the paper) to spot areas you can improve.

- While your pencil is sharp, go over fine details and make lines cleaner. As it gets duller, add shading.

- Turn your drawing as you draw to avoid smudging.

Using ovals, rods and joints, you can make two pachies about to butt heads.

- Finally, clean up any smudges with your eraser.

Stegosaurus

STEG-O-SAW-RUS

"Roof lizard." Biggest known stegosaurid. Late Jurassic; Colorado, Oklahoma, Utah and Wyoming, USA. Up to 30 feet (9m) long; weighed up to 2 tons. Spikes on end of tail for defense. Scientists still debate what those big plates did, and whether they were staggered or in even pairs.

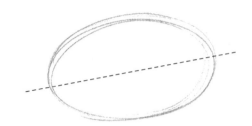

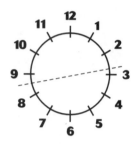

Use the clock face to compare angles of lines and ovals.

Draw a tilted, horizontal oval.

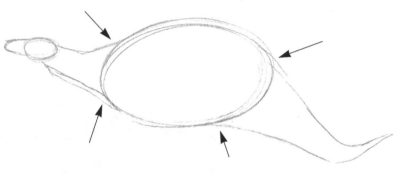

Draw a small, flat oval for the head, with a bump for the nose. Add two curving lines for the neck. Notice how the lines join the bottom of the big oval. They seem to flow right into it. Add lines for the tail, coming to a point at the end.

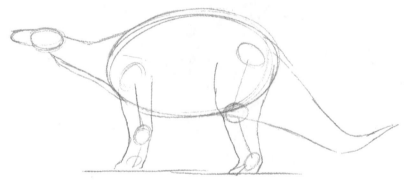

Using rods and joints (see pages 4-5), place the legs, then add outlines.

Add the remaining two legs. Draw the eye, nose and mouth. Carefully erase rods and joints, and parts of ovals that overlap. Darken the bottom outline.

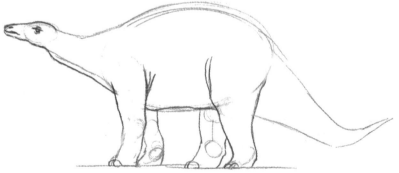

Always start out *lightly!*

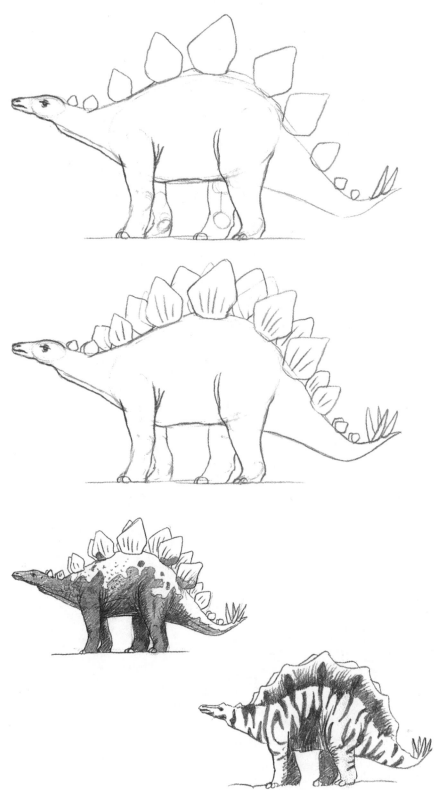

Draw a line of diamond-shaped armor plates along the back. Draw two tail spikes.

Add another row of plates. Make vertical lines on them. Draw the remaining two spikes on the tail.

- Finish your drawing by adding texture and shading. Use your imagination! Did Stego have a camouflage pattern? Or perhaps stripes, like a zebra? And were those plates really bare, or perhaps supporting a fin on the back? *Who knows?*

- Look at your drawing in a mirror (or through the back of the paper) to spot areas you can improve.

- While your pencil is sharp, go over fine details and make lines cleaner. As it gets duller, add shading.

- Turn your drawing as you draw to avoid smudging it with your hand.

- Finally, clean up any smudges with your eraser.

Kentrosaurus

KEN-TRO-SAW-RUS

"Pointed lizard." Late Jurassic; Tanzania,
East Africa. 17 feet (5m) long.
Stegosaurus-like plates become spikes
farther back. Extra spikes stuck out
sideways from the hip.

Use the clock face to
compare angles of lines
and ovals.

Lightly draw a tilted oval.

Add two long, swooping
lines for the tail, then draw a
small oval for the head, and
two lines for the neck. Draw
the eye and mouth.

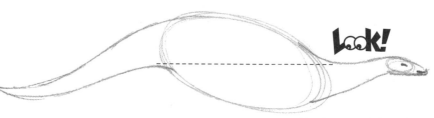

The bottom of the tail
and the top of the neck
are level.

Draw a line for the ground,
and use rods and joints (see
pages 4-5) to create the
front leg.

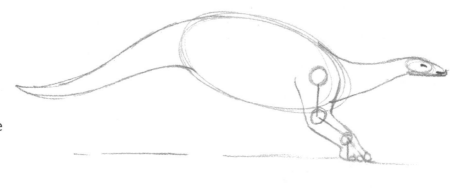

Add the rear leg, using rods
and joints (see pages 4-5).

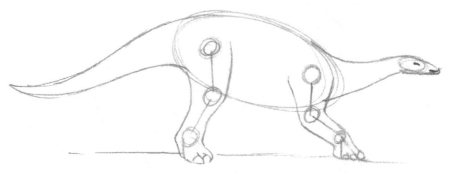

Always start out *lightly*!

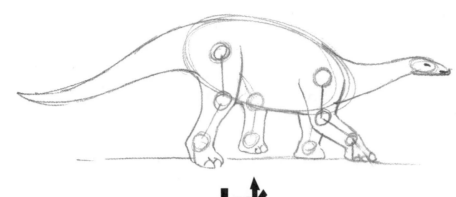

Now draw the other two legs. **Look** how one rear leg ends *above* the ground line. When you add the *cast shadow* underneath, it will appear that you're looking slightly down at the dinosaur.

Extra spikes on the hips.

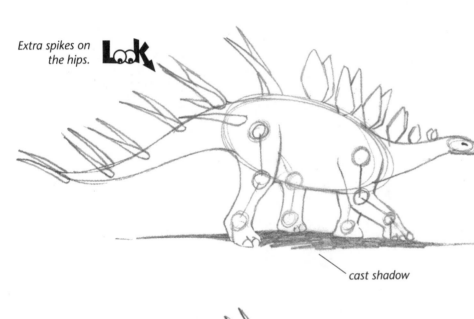

cast shadow

Add pairs of pointed plates on the front half of the dinosaur, and pairs of spikes on the back. Notice the extra pair of spikes on the hip. Try turning your paper sideways when you draw the spikes.

Now, carefully erase overlapping ovals, rods and joints. add the *cast shadow.*

• Look at your drawing in a mirror (or through the back of the paper) to spot areas you can improve.

• While your pencil is sharp, go over fine details and make lines cleaner. As it gets duller, add shading.

• Finally, clean up any smudges with your eraser.

Kool kentrosaur!

Maiasaura

MY-A-SOR-A

"Good mother lizard." Cretaceous; Montana, USA. Up to 30 feet (9m) long. In 1978 scientists discovered fossilized baby Maiasaura and eggs around a mound-shaped nest, the first evidence of dinosaurs with organized family structure.

Start with a a tilted oval for the dinosaur's body.

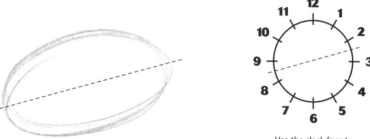

Use the clock face to compare angles of lines and ovals.

Look where the top of the tail joins the body. From that point, draw the line for the top of the tail. Then add the bottom of the tail, which flows smoothly into the bottom of the oval.

Draw a circle for the head. Place the eye inside it. Add the curving lines of the neck, flowing into the ovals at either end.

Using rods and joints (see pages 4-5), draw the hip, knee, ankle and foot. Lightly add the outline of the leg.

Repeat for the arm. Make the hand higher than the foot. Draw lines for the inside and outside of the nest. Draw eggs in the nest.

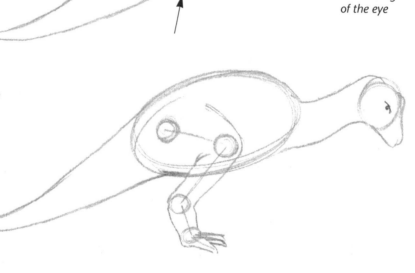

Notice the angle of the eye

outside of nest

inside of nest

! *You only see part of each egg.*

Always start out *lightly*!

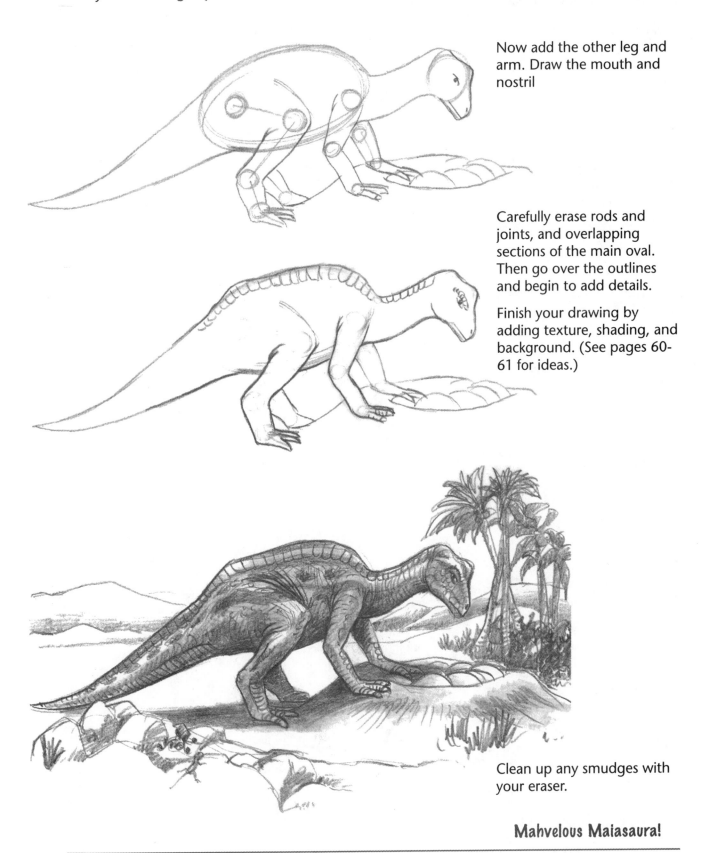

Now add the other leg and arm. Draw the mouth and nostril

Carefully erase rods and joints, and overlapping sections of the main oval. Then go over the outlines and begin to add details.

Finish your drawing by adding texture, shading, and background. (See pages 60-61 for ideas.)

Clean up any smudges with your eraser.

Mahvelous Maiasaura!

Plesiosaurus

PLEES-EE-O-SAW-RUS

"Ribbon reptile." Jurassic; Germany, England. 6-28 feet long (2-9m). Swam by flapping front flippers up and down. Probably moved its neck very quickly to catch fish. Alas, not a dinosaur but a swimming reptile.

Draw a horizontal oval for the body, and a smaller one for the head.

Draw the swooping lines of the neck. Add the tail.

Draw the centerline of the back.

Add limbs, with flippers instead of feet.

Draw the mouth and eye. Carefully erase the original oval at neck and tail.

Add shading to add form to the body, and you have a...

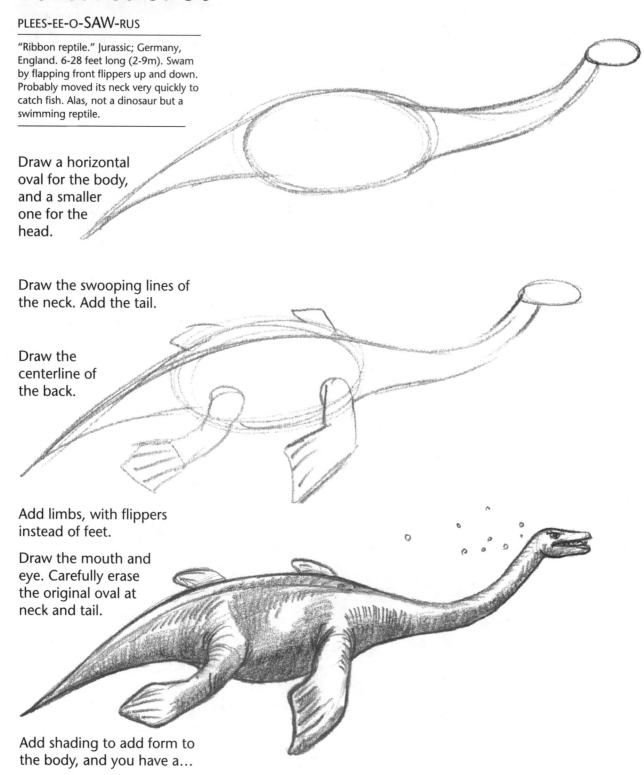

...pleasing Plesiosaurus!

TRIANGLESAURS

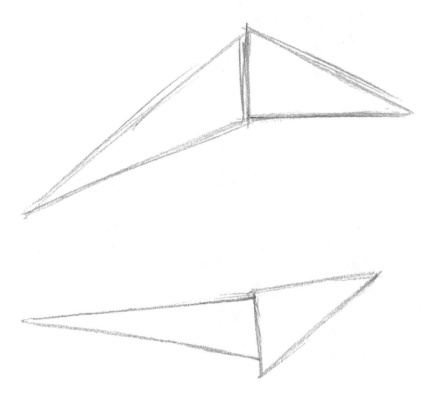

When you look at your subject, you may spot curving lines that are easy to draw. Or it might seem obvious to start with an oval.

But sometimes, triangles will jump out at you...draw them!

Can you spot the dinosaurs lurking in these triangles?

Looking for Triangles

When artists and illustrators sit down to draw a realistic picture, they almost always have some sort of *reference material.* In other words, they look at something as they draw it.

But no people see things exactly alike.

One person might see big swooping lines and start the drawing as a linosaur.

Another person might start with an oval for the body, making an ovalsaur.

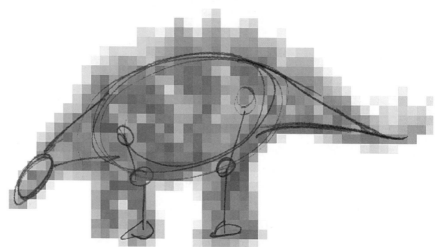

And a third person might see triangles, and use them to begin the drawing.

Triangles are everywhere. When you look at your subject, look for curving lines and look for ovals...but also look for triangles.

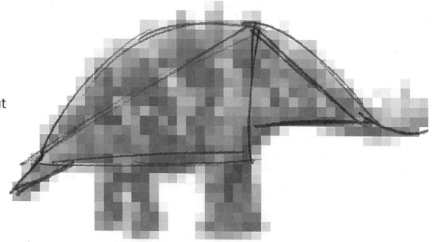

Always start out *lightly!*

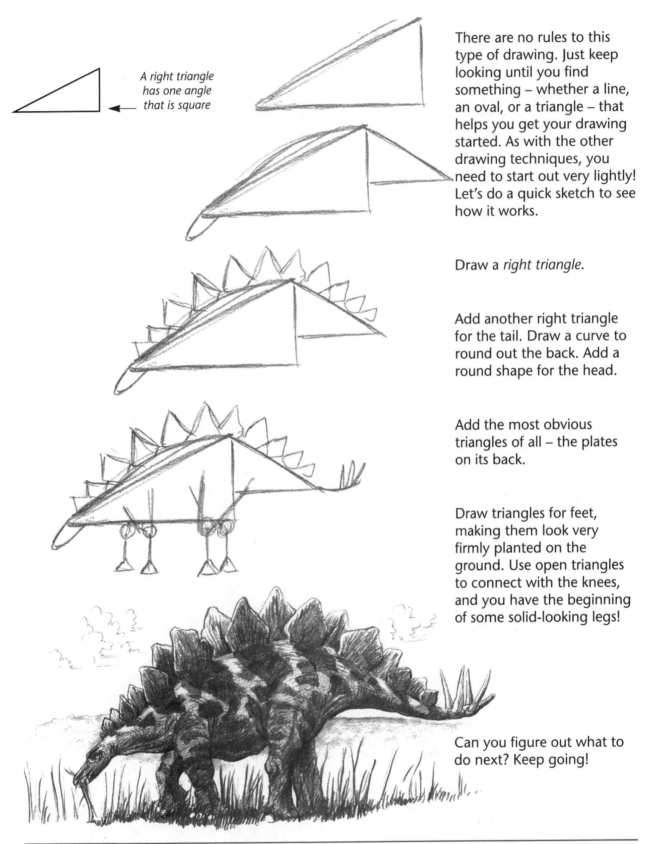

A right triangle has one angle that is square

There are no rules to this type of drawing. Just keep looking until you find something – whether a line, an oval, or a triangle – that helps you get your drawing started. As with the other drawing techniques, you need to start out very lightly! Let's do a quick sketch to see how it works.

Draw a *right triangle*.

Add another right triangle for the tail. Draw a curve to round out the back. Add a round shape for the head.

Add the most obvious triangles of all – the plates on its back.

Draw triangles for feet, making them look very firmly planted on the ground. Use open triangles to connect with the knees, and you have the beginning of some solid-looking legs!

Can you figure out what to do next? Keep going!

Tyrannosaurus

TIE-RAN-O-SAW-RUS

"Tyrant lizard." Cretaceous; western North America, china. Ate meat. Lots of it. 39 feet (12m) long; 18.5 feet (5.6m) tall; weighed 7 tons—as much as an African elephant. Skull measured 4 feet (1.2m). Saw-edged teeth could be 7 inches (18cm) long.

A right triangle has one angle that is square

Start by drawing (very lightly!) a *right* triangle.

Draw another long triangle connecting to it and pointing downward.

Using more triangles, make the shape of the thigh and calf of the dinosaur. Add part of a triangle for the other leg. Notice how the triangles look like legs already!

Make single lines for the bottom part of the leg, and small triangles for the feet. Draw one foot at an angle and slightly higher.

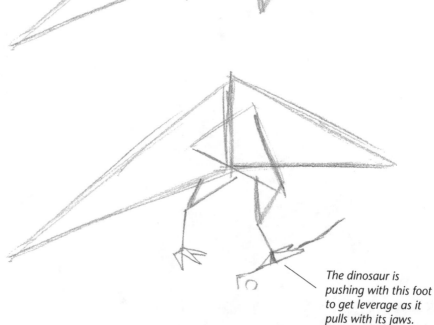

The dinosaur is pushing with this foot to get leverage as it pulls with its jaws.

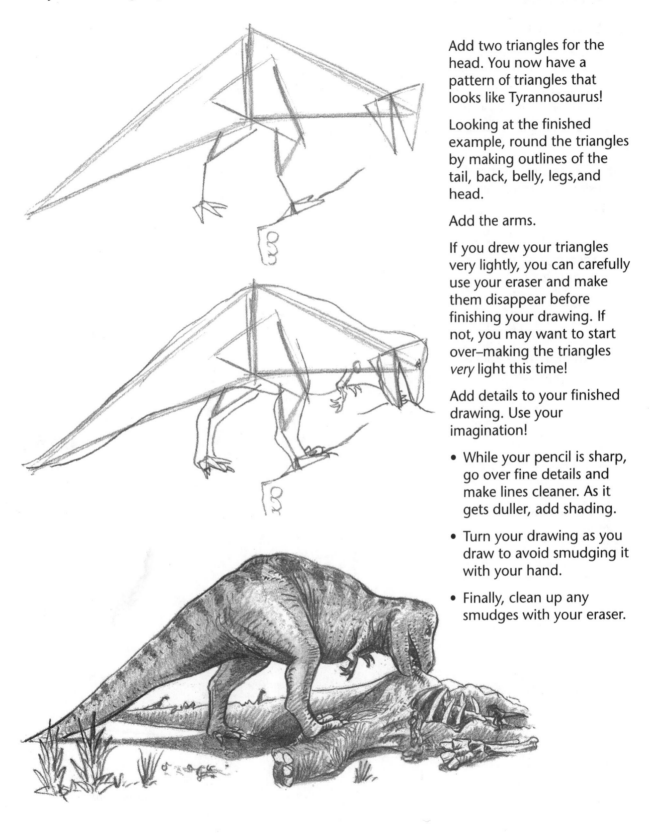

Add two triangles for the head. You now have a pattern of triangles that looks like Tyrannosaurus!

Looking at the finished example, round the triangles by making outlines of the tail, back, belly, legs, and head.

Add the arms.

If you drew your triangles very lightly, you can carefully use your eraser and make them disappear before finishing your drawing. If not, you may want to start over–making the triangles *very* light this time!

Add details to your finished drawing. Use your imagination!

• While your pencil is sharp, go over fine details and make lines cleaner. As it gets duller, add shading.

• Turn your drawing as you draw to avoid smudging it with your hand.

• Finally, clean up any smudges with your eraser.

Velociraptor

VEL-**OS**-I-**RAP**-TOR

"Swift plunderer." Late Cretaceous; Mongolia, china, and Khazakhstan. 6 feet (1.8m) long. Probably hunted in packs, attacking with claws and teeth. In 1971 a specimen was found that had died while attacking a Protoceratops.

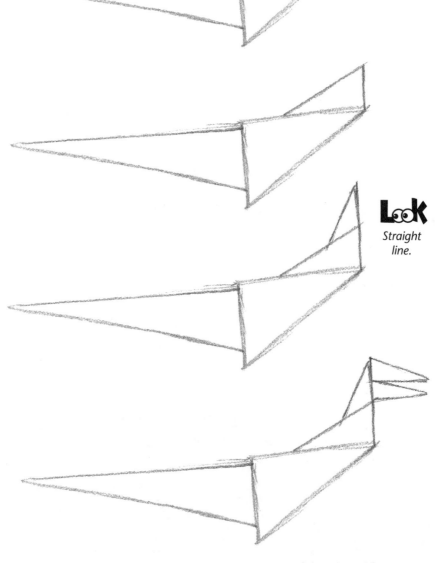

A right triangle has one angle that is square. This triangle tilts slightly.

Start your raptor drawing with a slightly tilted *right triangle*.

Add a second, much longer triangle for the tail.

Draw a third triangle above the first triangle...

LOOK

Straight line.

...and yet another triangle above it!

Now make two triangles for the jaws.

Origamisaurus?

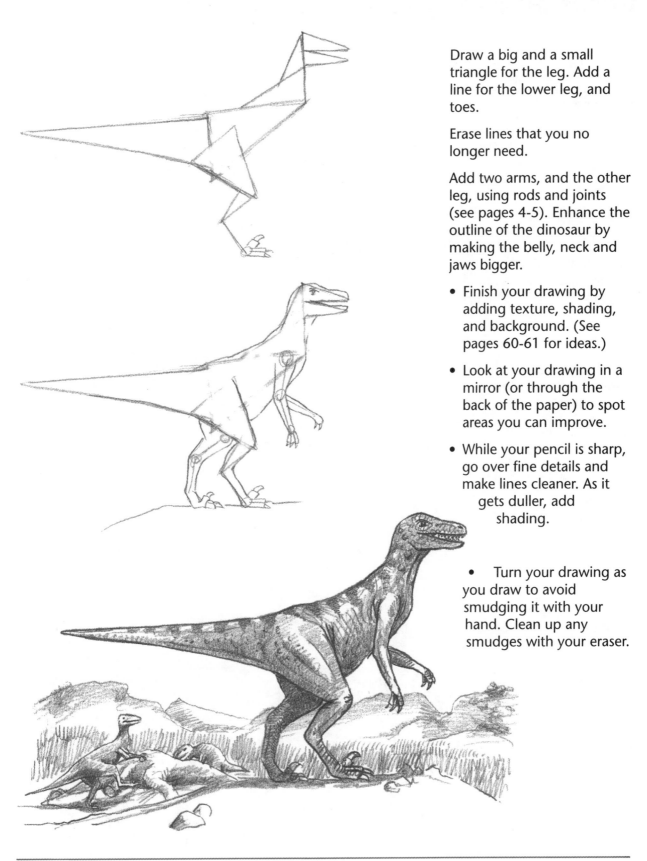

Draw a big and a small triangle for the leg. Add a line for the lower leg, and toes.

Erase lines that you no longer need.

Add two arms, and the other leg, using rods and joints (see pages 4-5). Enhance the outline of the dinosaur by making the belly, neck and jaws bigger.

• Finish your drawing by adding texture, shading, and background. (See pages 60-61 for ideas.)

• Look at your drawing in a mirror (or through the back of the paper) to spot areas you can improve.

• While your pencil is sharp, go over fine details and make lines cleaner. As it gets duller, add shading.

• Turn your drawing as you draw to avoid smudging it with your hand. Clean up any smudges with your eraser.

Compsognathus

KOMP-sog-NATH-us

"Pretty jaw." Jurassic; southern Germany, southeast France. Ate small animals. Up to 2 feet (60cm) long. This chicken-sized dinosaur probably lived and hunted in small herds, possibly attacking larger animals in a group.

A right triangle has one angle that is square. This triangle tilts slightly.

Start by lightly drawing a right triangle.

Add another right triangle pointing the other direction. Make the tops of both form a straight line.

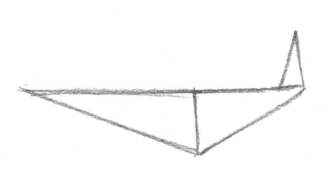

From the end of the first triangle, make another triangle sticking up for the neck…

…and from it, a triangle sticking out for the head.

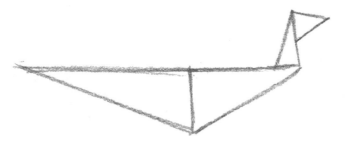

Lightly draw a titling triangle to make the top of the leg.

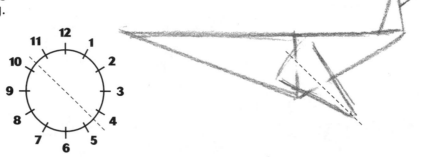

Use the clock face to compare angles.

Erase parts of triangles when you no longer need them, or if they become confusing.

Always start out *lightly*!

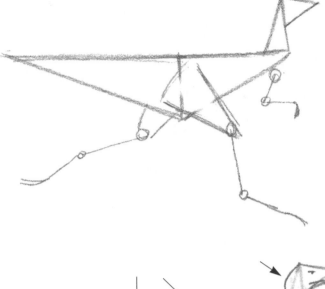

Complete the leg with rods and joints (see pages 4-5). Add rods and joints for the other leg and arm.

Now add the round curves of the outline, following the example.

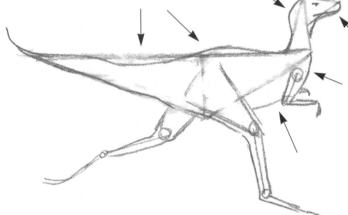

- Finish your drawing by adding texture, shading, and background. (See pages 60-61 for ideas.)

- Look at your drawing in a mirror (or through the back of the paper) to spot areas you can improve.

- While your pencil is sharp, go over fine details and make lines cleaner. As it gets duller, add shading.

- Turn your drawing as you draw to avoid smudging it with your hand.

- Finally, clean up any smudges with your eraser.

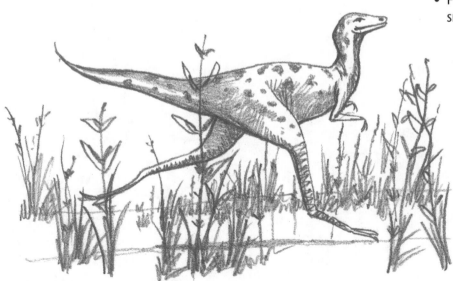

What a cute little fellow! I wonder if he's friendly…?

Deinonychus

die-no-NIKE-us

"Terrible claw." Early Cretaceous; Montana, USA. 10-13 feet (3-4m) long. Larger then *Velociraptor,* it could kick into the belly of an animal and tear it open with its large (5 inch/12.7cm) scythe-like claw. There were also three heavy claws on each hand, with powerful arm muscles to make them effective weapons. This would be a dinosaur to avoid!

Always start out *lightly!*

A right triangle has one angle that is square

Start by lightly drawing a right triangle for the body.

Add another triangle pointing up, the other direction, for the tail.

Make another triangle on top of the first…

…and from it, two triangles for the jaws. Draw the eye.

Add two more triangles to make the top and bottom parts of the leg.

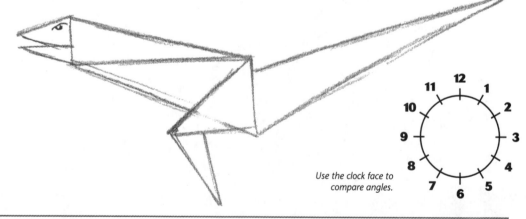

Use the clock face to compare angles.

```
        12
   11        1
10              2

9               3

   8         4
     7     5
        6
```

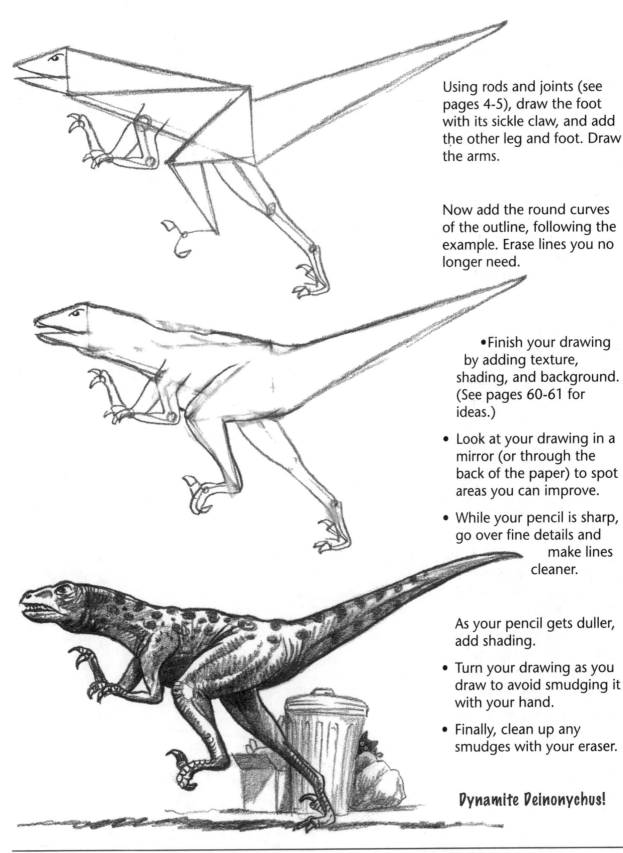

Using rods and joints (see pages 4-5), draw the foot with its sickle claw, and add the other leg and foot. Draw the arms.

Now add the round curves of the outline, following the example. Erase lines you no longer need.

• Finish your drawing by adding texture, shading, and background. (See pages 60-61 for ideas.)

• Look at your drawing in a mirror (or through the back of the paper) to spot areas you can improve.

• While your pencil is sharp, go over fine details and make lines cleaner.

As your pencil gets duller, add shading.

• Turn your drawing as you draw to avoid smudging it with your hand.

• Finally, clean up any smudges with your eraser.

Dynamite Deinonychus!

Pteranodon

TER-AN-O-DON

"Winged toothless." Late Cretaceous; Wyoming, USA. Wing span of 23 feet (7m); greater than any known bird. Probably only weighed about 37 lbs (17kg). Long, toothless jaw was counterbalanced by bony crest at top of head. Probably scooped fish out of the ocean, as pelicans do today – and probably had a pelican-like pouch as well.

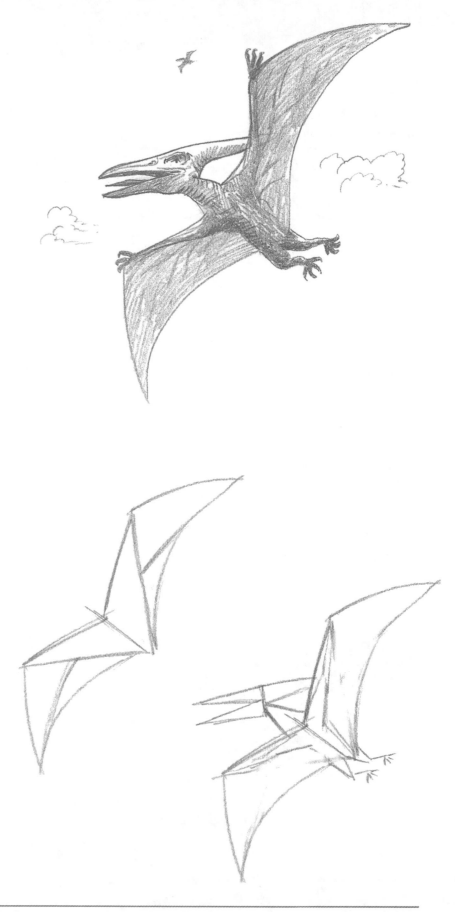

There's no right or wrong way to using triangles in drawing. Just remember that they can be a handy tool.

For example, you may not need all the triangles I used in the Pteranodon's wing. Use as many as you find helpful!

- Look at your drawing in a mirror (or through the back of the paper) to spot areas you can improve.

- While your pencil is sharp, go over fine details and make lines cleaner. As it gets duller, add shading.

- Turn your drawing as you draw to avoid smudging it with your hand.

- Finally, clean up any smudges with your eraser.

CHAPTER 4
SOLIDSAURS

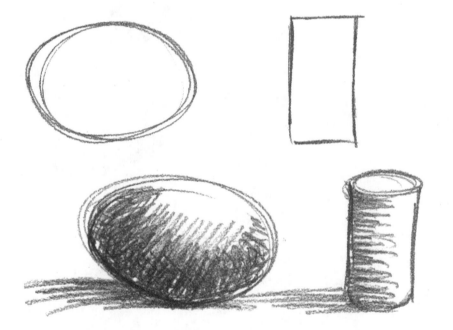

As your dinosaur drawings improve, you may want the extra challenge of making dinosaurs that look as though they're coming right toward you.

In order to do this, it helps to understand basic forms and how to draw them.

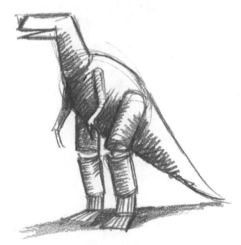

Basic forms

To draw solidsaurs, you'll find three forms most useful: cylinders, cones, and rounded forms based on ovals.

Shading makes your solid form look solid.

But for shading to work,it needs to follow the *contours* of the form. The middle drawing of each form shows *contour lines.* When you add shading, make the lines of the shading follow these lines.

Combined, the forms can make bodies, legs, and more....

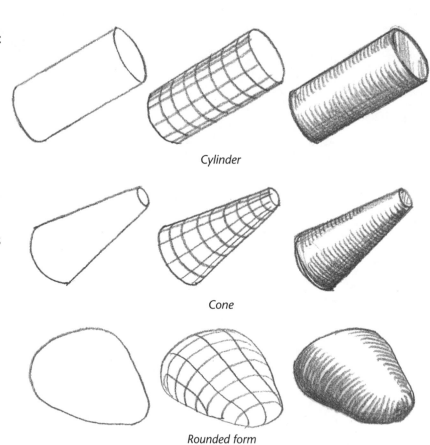

Cylinder

Cone

Rounded form

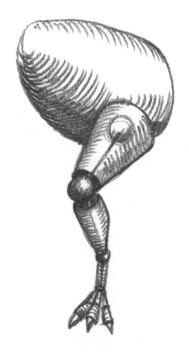

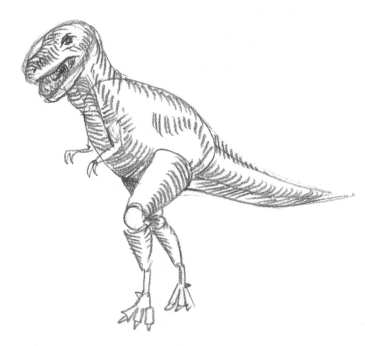

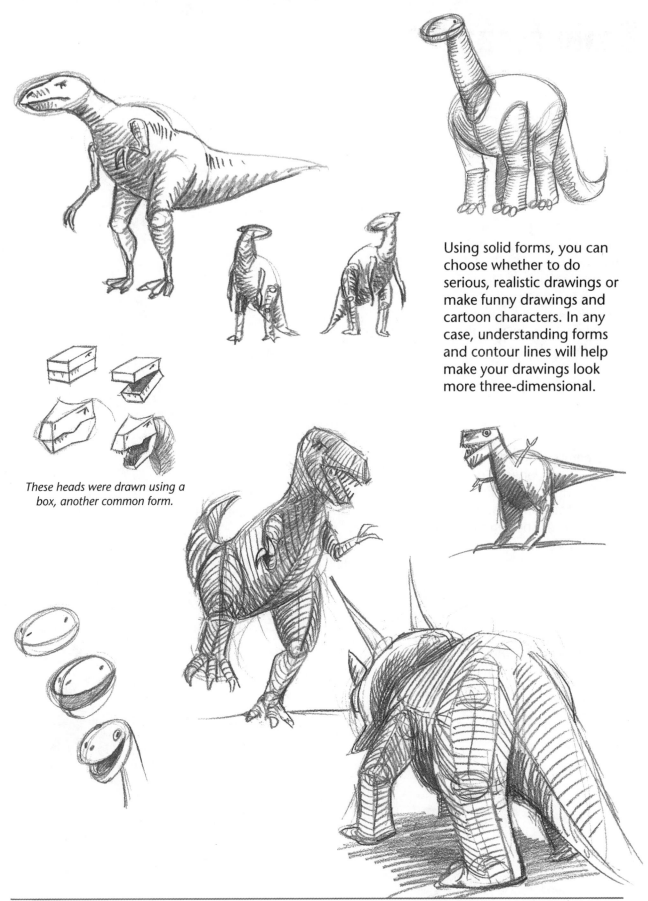

Using solid forms, you can choose whether to do serious, realistic drawings or make funny drawings and cartoon characters. In any case, understanding forms and contour lines will help make your drawings look more three-dimensional.

These heads were drawn using a box, another common form.

Lambeosaurus

LAM-be-oh-SAW-rus

"Lambe's lizard" Cretaceous; western North America. About 50 feet (15m) long. The tall, showy head crest was a hollow bone. The nostrils ran up from the snout through the crest.

Start with a vertical, slightly tilted oval for the body. Add the lines for the tail. Draw the oval for the head, with eye and crest. Add almost vertical neck lines. Draw the centerline of the body.

Use a combination of cylinders and cones to draw the leg, with curving lines showing the contours. Add more contour lines on the tail and belly.

Add the other leg and arms.

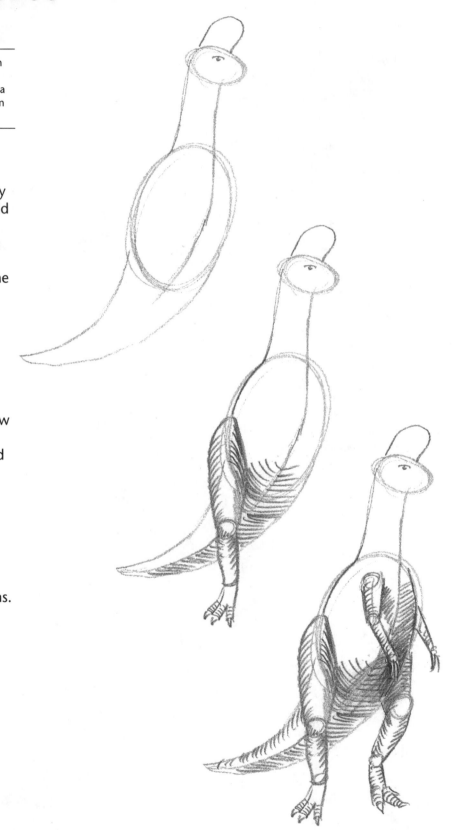

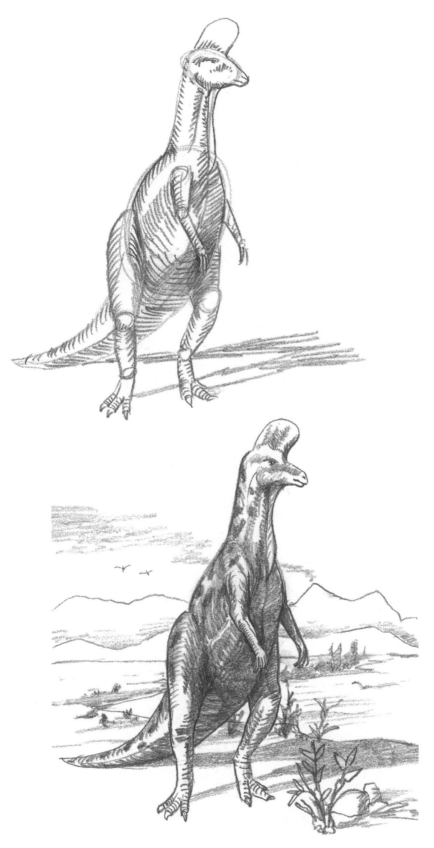

Finish details in the head and neck, and add more shading to round out the body.

- Finish your drawing by adding texture, shading, and background. (See pages 60-61 for ideas.)

- Look at your drawing in a mirror (or through the back of the paper) to spot areas you can improve.

- While your pencil is sharp, go over fine details and make lines cleaner. As it gets duller, add shading.

- Turn your drawing as you draw to avoid smudging it with your hand.

- Finally, clean up any smudges with your eraser.

Lovely Lambeosaurus!

Scelidosaurus

SKEL-**IDE**-OH-**SOR**-US

"Limb lizard." Early Jurassic; southern England, Tibet. 13 feet (4 m) long. Probably a slow-moving dinosaur, it had very sturdy legs and was armored with bony knobs on its back. It's one of the few dinosaurs where fossils show an impression of the skin!

Use the clock face to compare angles of lines and ovals.

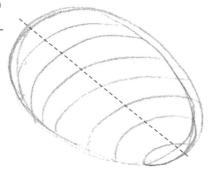

Draw a flat, tilted oval with contour lines showing the form.

Add the neck and head. Use contour lines wrapping around the neck to create *foreshortening* (making it look like it's coming toward you). Add other lines where the rows of bumps will be on the back.

Using cylinders, draw the front leg.

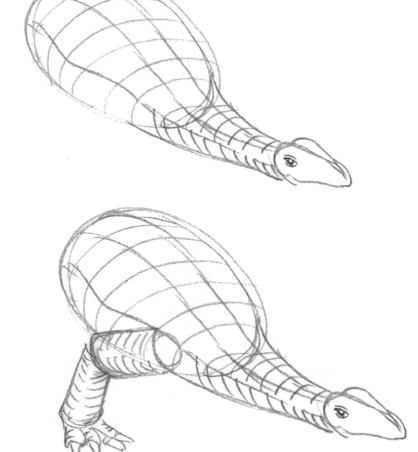

Always start out *lightly*!

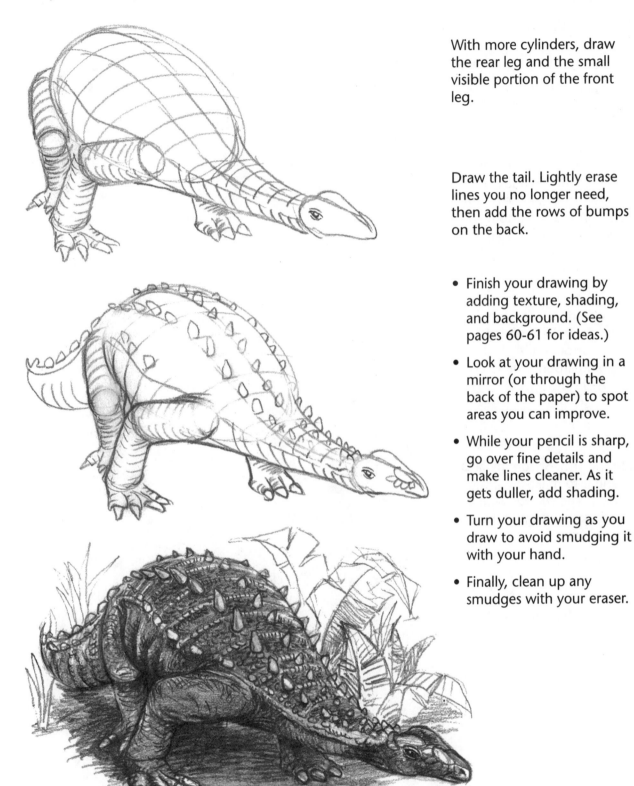

With more cylinders, draw the rear leg and the small visible portion of the front leg.

Draw the tail. Lightly erase lines you no longer need, then add the rows of bumps on the back.

- Finish your drawing by adding texture, shading, and background. (See pages 60-61 for ideas.)

- Look at your drawing in a mirror (or through the back of the paper) to spot areas you can improve.

- While your pencil is sharp, go over fine details and make lines cleaner. As it gets duller, add shading.

- Turn your drawing as you draw to avoid smudging it with your hand.

- Finally, clean up any smudges with your eraser.

Segnosaurus

SEG-no-SAW-rus

"Slow lizard." Cretaceous; southeast Mongolia. May have been 30 feet (9m) long. This dinosaur is known only from a partial skeleton. The best guess is that it might have been a swimmer and fed on fish.

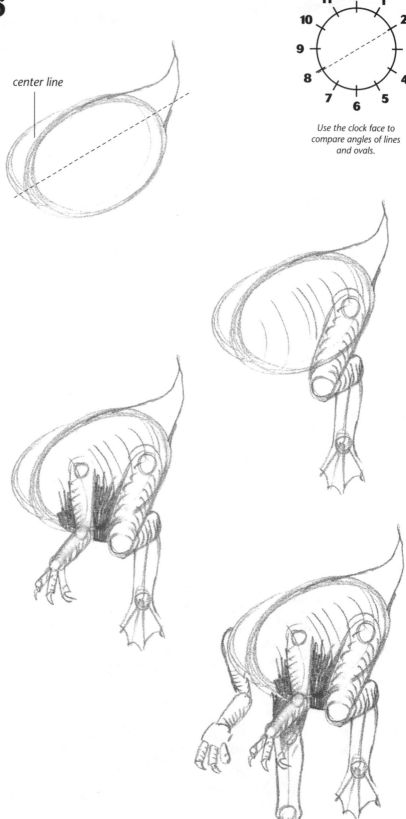

center line

Use the clock face to compare angles of lines and ovals.

Draw a tilted oval. Add the center line of the body, and extend it to make the top of the tail. Add the bottom line of the tail.

With cylinders, rods and joints, draw the back leg. Make contour lines wrapping around the leg and the body.

Add the arm. Shade the area behind it to make a dark shadow. The *contrast* of the dark makes the light arm appear closer.

Add the other arm and leg in a similar manner.

Always start out *lightly!*

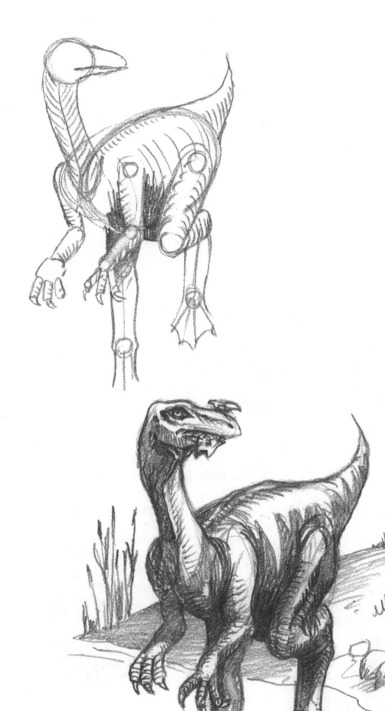

Draw the neck and head. Use contour lines to show the form of the neck.

- Finish your drawing by adding texture, shading, and background.

- Look at your drawing in a mirror (or through the back of the paper) to spot areas you can improve.

- While your pencil is sharp, go over fine details and make lines cleaner. As it gets duller, add shading.

- Turn your drawing as you draw to avoid smudging it with your hand.

- Finally, clean up any smudges with your eraser.

Sensational Segnosaurus!

Finishing Touches

Before you add shading or texture, carefully remove lines that you don't want in the finished drawing.

It's OK if you erase some of the "good" lines. You'll go over them again to "sharpen" them.

Some paper erases well. Some paper doesn't. Don't be discouraged if erasing messes up your drawing, but do try to find a good "erasing" paper. Draw more lightly next time so you don't have as much to erase!

Erase lines you don't need in the final drawing: rods and joints, and where parts overlap.

A kneadable eraser starts out square, but you bend and twist it so you can erase small areas…a great help if you can find one.

Next, build tones (light and dark) by shading with a dull pencil. Don't just scribble with your pencil in every direction: follow the *contours* of the form.

A blending stump looks like a pencil made of paper. Use it or a rolled-up wad of paper to smooth shaded areas

With a blending stump or small rolled-up wad of paper, you can smudge the shading to make it very smooth.

While your pencil is sharp, add details and texture. Go over lines, making them sharper and stronger.

Add patterns to the skin, making them follow the *contours* of the body whenever possible.

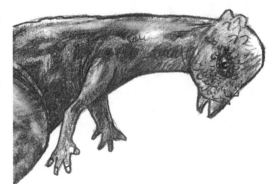

Follow contours when you shade. In the lower box, the stripes and shading show a curved contour, similar to the curve of an arm for leg. In contrast, the upper box looks flat.

Backgrounds

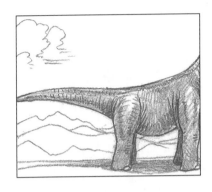

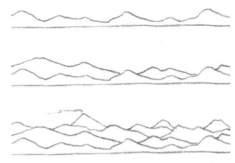

Adding background details can make your drawing much more fun to look at. For a quick background, draw a squiggly line of mountains. Add another, and another. Notice how the hills in front *overlap* those further away.

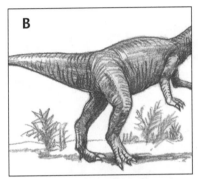

Add plants, simple or complicated:

A. *Simple pencil strokes suggest grass, and create a sense of scale for this small dinosaur.*

B. *Bushier plants make this dinosaur look larger.*

C. *Plants getting smaller create a sense of depth.*

D. *Broad, leafy plants as tall as the dinosaur add realism to the drawing.*

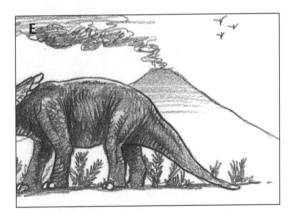

E. *Plants that hardly reach its knees make the dinosaur look bigger. But the volcano looks bigger still! Notice overlapping.*

Use your imagination!

Some final thoughts

Remember...

One of the great secrets of our world is that behind every success there's always plenty of practice. The people who do amazing feats of daring, skill, or ingenuity have been practicing, often for much longer than you'd imagine. They've probably failed more often than you can imagine, too, so don't waste time being discouraged. If your drawings don't look exactly the way you'd like them to (especially the first try), **stop, look,** and **try again!**

Save your drawings!

Whenever you do a drawing—or even a sketch—put your initials (or autograph!) and date on it. And save it. You don't have to save it until it turns yellow and crumbles to dust, but do keep your drawings, at least for several months. Sometimes, hiding in your portfolio, they will mysteriously improve! I've seen it happen often with my own drawings, especially the ones I *knew* were no good at all, but kept anyway.

If you don't have your own portfolio, here's a way to make one inexpensively (or you can buy one at an art supply store).

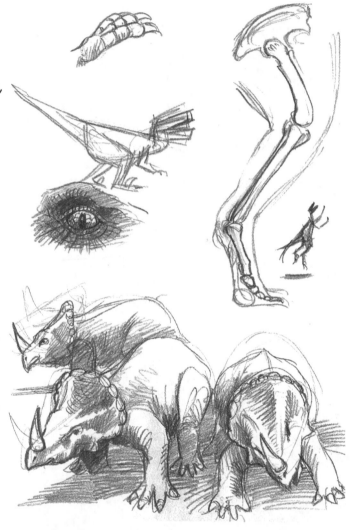

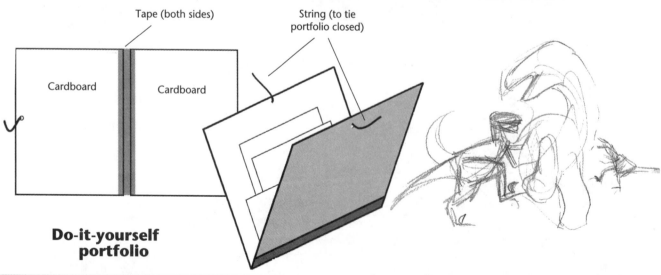

Tape (both sides)

String (to tie portfolio closed)

Cardboard Cardboard

Do-it-yourself portfolio

Index

Allosaurus.....................................10

Anchiceratops16

Ankylosaurus28

Apatosaurus22

Camarasaurus................................8

Compsognathus...........................46

Deinonychus48

Dsungaripterus.............................20

Kentrosaurus34

Lambeosaurus54

Maiasaura.....................................36

Ouranosaurus................................14

Pachycephalosaurus30

Parasaurolophus............................26

Plesiosaurus.................................38

Pteranodon50

Scelidosaurus...............................56

Segnosaurus.................................58

Stegosaurus............................32, 40

Stenonychosaurus12

Triceratops24

Tuojiangosaurus............................18

Tyrannosaurus..............................42

Velociraptor..................................44